Do Design

Why beauty is key to everything

Alan Moore

Published by
The Do Book Company 2016
Works in Progress Publishing Ltd
thedobook.co

Photography copyright:
p9 © Richard Ross
p10, 80, 85 © Marzena Skubatz
p16 © Julian Calverley
p26 © Joshua Lake
p36, 86 © Tashi Mannox
p45 © Richard Sweeney
p46 © Alan Moore
p59 © Solidwool
p64 © Laurent Nivalle
p68 © Howard Sooley
p72, 99, 100 © Jonathan Cherry
p88 © Gränsfors Bruk
p92 © Andrew Montgomery

Reproduced with kind permission.

A CIP catalogue record for this book
is available from the British Library

ISBN 978-1-907974-28-1

To find out more about our company,
books and authors, please visit
thedobook.co or follow us **@dobookco**

5% of our proceeds from the sale of
this book is given to The DO Lectures
to help it achieve its aim of making
positive change **thedolectures.com**

Cover designed by James Victore
Book designed and set by Ratiotype

Printed and bound by OZGraf Print
on Munken, an FSC® certified paper

For all the people who have designed
and created beauty in this world.

For those striving to bring beauty
into this world.

For those who will create beauty
and share it with the world.

Contents

Beauty without vanity
Strength without insolence
Courage without ferocity

John Hobhouse (1786–1869)

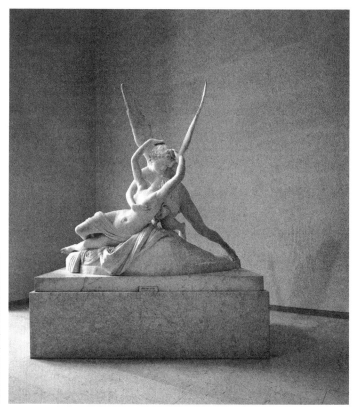

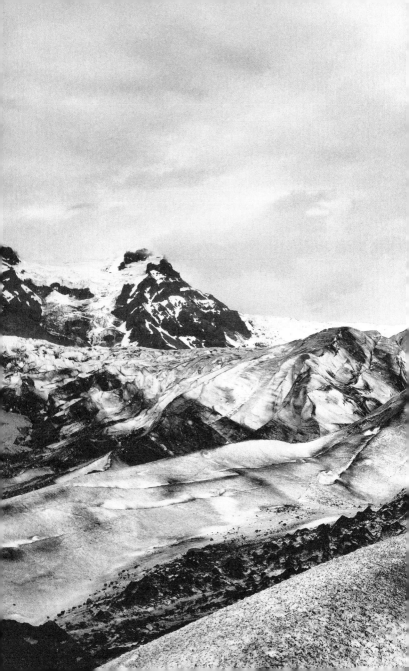

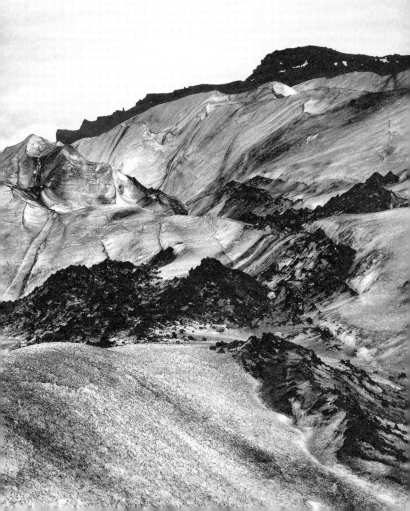

Beauty

1

Creating beauty in everything and why it matters

I have always been fascinated by beautiful things: architecture, furniture, books. Beautiful things are prepared with love. The act of creating something of beauty is a way of bringing good into the world. Infused with optimism, it says simply: Life is worthwhile.

The effort to create enduring beauty is not dependent on style but truth. Beauty is what lends things their immortality.

These objects outlive their creators. They are a gift their creators give to the world. Beauty is resilient, it is life-affirming, it gives back to create more life.

We were all born inherently creative. We all have the capacity to bring beautiful things into this world and should be unapologetic about wanting to create them, whatever they are.

Ask yourself this simple question: Do I want a beautiful meal or a dreary one? A beautiful relationship or an ugly one? To live a beautiful life or an average one? Work for, or create, a remarkable business, product or service, or mediocre ones? There is of course range in what we call beauty, but in the end the truth is that beautiful things endure.

Whether you are an artisan, an entrepreneur, or a CEO searching for some homespun hard-won wisdom, *Do Design* hopes to inspire, guide and show how we might so elegantly create for enduring beauty.

I would like to invite you to journey with me to explore how we can design and create beautiful products, services, art and culture, stuff filled with so much optimism that it lifts us up.

What did astronaut Edgar Mitchell have to say about beauty?

When astronauts go into space and look down at the earth they find themselves having a deep spiritual connection with it that is both shocking and beautiful. Theirs is a profound epiphany – a realisation of the inseparable relationship between the cosmos, the earth and humanity. It is a moment of transformation, of catharsis, an irreversible cognitive shift.

This experience is called the overview effect – the moment of seeing at first hand the reality of the earth in space. It is immediately understood to be a tiny, fragile ball of life, hanging in the void, shielded and nourished by a paper-thin atmosphere. Again and again astronauts talk about the overwhelming, almost indescribable beauty, and an awareness that the sun, the moon and the earth, our universe, us, are all made from the same atomic stuff. We are all interconnected at the level of atoms. The earth is one system, we are all part of that system and there is a certain unity to it, which also has implications for us all.

Edgar Mitchell, scientist, astronaut and lunar pilot from the third lunar landing, experienced this transcendental moment. He wanted to understand it better, more deeply. Returning to earth, Mitchell sought out literature that

might explain what was to him a profound, life-changing, even sacred encounter. He found an explanation not in modern religious or scientific texts, but in ancient literature. The term used was *salva corpus amanti*, literally translated as 'save the lover's body'. This is Mitchell's interpretation of this phrase:

> *'You see things as you see them with your eyes but you experience them emotionally and viscerally as if it was ecstasy and a sense of total unity and oneness. The molecules in my body and the molecules in my partners' bodies, and in the spacecraft had been prototyped in some ancient generation's stars. In other words, it was pretty obvious ... we're all stardust.'*

From space, the astronauts tell us, national boundaries vanish, the conflicts that divide people become less important, and they feel an overwhelming need to create a planetary society with the united will to protect. This becomes both blindingly obvious and imperative. They speak of unity, rather than discord. They speak about humanity rather than nationality, acquiring a deeper insight into what unity really means.

Many astronauts come home with the purpose and conviction that they must contribute to the future of both the natural world and humanity. They have a calling, an incessant striving for a better way to live, to exist.

Shaker Rocking Chair

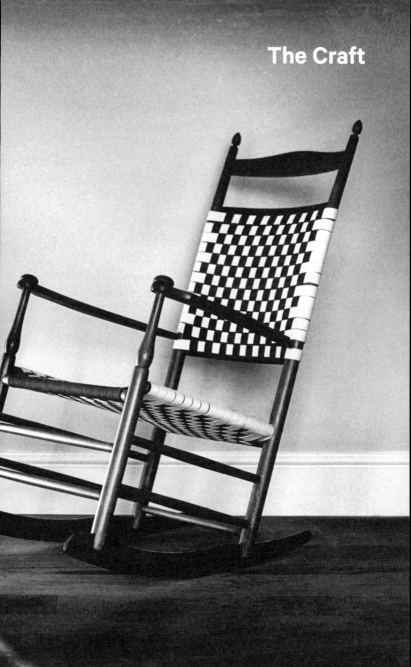

The most beautiful question
in the world

Theoretical physicist and Nobel prize winner Frank Wilczek is fascinated with the symmetries and harmonies that at their most fundamental level are the DNA to nature's design model. He asks the question: Is the world a work of art?

Albert Einstein and physicist Paul Dirac both generated theories about our universe that are often described as so beautiful that they are great works of art. Einstein's was the theory of relativity, a beautiful description of how the universe works symmetrically. The Dirac equation is the symmetrical relationship of electrons to the natural world. Harmony, symmetry and maths all point to this atomic elegance.

In understanding the design of our world, there is a gravitational pull towards beautiful theories to describe its inner workings. Long ago, we intuited beauty as a key to nature's foundational design model.

Today we explore 'supersymmetry' when searching for the Higgs Boson. Supersymmetry is often described as being too beautiful to be entirely wrong. This elegant theory suggests every elementary type of particle we know of in nature has superpartners, which dance

interactively with each other; but for some reason nature has hidden these beautiful exchanges from view. Many believe supersymmetry takes us towards a fully unified description of nature at the deepest level. Several of the world's leading theoretical physicists draw encouragement from its surpassing mathematical beauty and the fact that, for the first time, it explains the very existence of gravity.

How beautiful is that?

The roots of design

The philosopher Ralph Waldo Emerson said the question of beauty takes us away from the surfaces to thinking about the core foundations of things. This insight is vital to understanding that good design can touch all our lives in the minutest detail – and good design is foundational to beauty and what we bring into the world.

By returning to our roots of making, crafting, designing, our world would be a better place to live.

We can use design to work on behalf of the human spirit, to uplift us physically and spiritually, to connect us to our human nature. Design elevates, nurtures and improves our lot. It intertwines our spiritual and material wellbeing.

The enduring utility, honesty and beauty in Shaker design

William Morris once said, 'Have nothing in your house that you do not know to be useful, or believe to be beautiful.' These are the words of a craftsman, dedicated to only bringing the good into the world. Morris's words across the Atlantic echoed the Shaker guiding principles of simplicity, utility and honesty in everything they designed and made.

Shaker design is so purposeful in concept and so economical in execution that it meets the William Morris criteria perfectly. I believe we have much to learn from the underlying principles of Shaker design.

Consider a Shaker chair: four posts, three slats, a handful of stretchers, a few yards of woollen tape for the seat. It could not be more simply made, but this is the work of a master craftsman – whose beliefs and purpose are manifest in the final product.

What really distinguishes Shaker design is something that transcends utility, simplicity and perfection – a subtle beauty that relies almost wholly on proportion. There is harmony in the parts of a Shaker object. And, in fact, there is harmony within and between all Shaker objects. Chairs, pails, bonnets, a dwelling room, a barn, a kitchen garden,

the land itself. The overriding Shaker belief was that the outward appearance of all things reveals their inner spirit.

The purpose of work for the Shakers was as much to benefit the spirit as it was to produce goods. Mastery of craft was a partnership with tools, materials and processes: gaining experience in patience that served the craftsman in many other areas of life. A job well done is not based upon watching the clock or fighting time – but in giving oneself to the task. The Shakers worked both as though they had a thousand years to live and as if they would die tomorrow. Their work transformed common objects into works of uncommon grace. The effort of a Shaker craftsman was dependent not on style but 'truth'.

Interestingly – there is little written about aesthetics or design in Shaker journals – it was the context and the culture in which they existed that was the invisible means that shaped their work. So, if we wish to create great work, to bring the new into the world in elegant and timeless ways, we must first address the key issues of purpose, context and process.

The Shakers also had one golden rule – back to William Morris: *Do not make that which is not useful.* And so it was their interpretation that all useful things should also be beautiful. God, as architect Mies van der Rohe said, was in the details and, you never know, an angel may come one day and sit on that chair – it had to be worthy of such an event.

It is said that the most appealing thing about Shaker design was its optimism. Those who would lavish care on a chair, a basket, a clothes hanger or a wheelbarrow clearly believed that life was and is worthwhile. And the use of every material – iron, wood, silk, tin, wool, stone – reveals the same grace. The Shakers recognised no justifiable difference in the quality of workmanship for any object,

no gradations in importance of the task. All must be done equally well. Whether it was the laying of a stone floor in the cellar, the making of closet doors in the attic, or the building of a meeting house, the work required nothing less than the skill, purpose and dedication of the craftsman.

Are these the lost values of another age, where time, grace, utility and beauty were always considered, shaping the way a people led their daily lives? Or might we look at our modern world and see perhaps that applying ourselves to creating only that which is useful and beautiful could be rewarding in many ways?

6
—

What world was Doug Engelbart trying to create?

Doug Engelbart was a man who gave considerable gifts to our world through his work in computational technological innovation. Engelbart pioneered *the mouse*, *hypertext*, and *video conferencing*. Think of how many people have used a mouse, or made video calls, all possible through his vision combined with his design capability. Today, we all rather nonchalantly Skype each other around the world at the click of a mouse.

Engelbart, like astronaut Edgar Mitchell, or the Shakers, wanted to 'raise up' our humanity. His purpose was to 'augment' our knowledge, thus enabling people to address big problems by allowing information to flow wherever it was needed so we could solve them, collectively.

For some Engelbart was an engineer, a geek building with technology. But we should not look at what he built but rather ask: What world was he trying to create? It was Engelbart's motivation, his purpose, his vision that should inspire us, so we can ask ourselves the same question: What world do *I* want to create?

Engelbart described what it was he wanted to create, even though it did not exist in any form. This is important: if you cannot describe a new destination, you will never

get there. You could say, the limits of our language are the limits of our world. A new language enables us to make the transition from where we are now, to where we need to get to. It lets us leap disciplinary boundaries. If we can't describe it, then we struggle to make it.

It was the rhetoric of public action used by pamphleteers and journalists in 18th century France that enabled the post-French Revolution construction of a different sort of functioning political society – a republic, where previously there had only been a monarchy and the divine will of God. William Gibson imagined and described a digital world called cyberspace; Doug Engelbart, among others, helped us all to get there.

Lofoten Islands, Norway

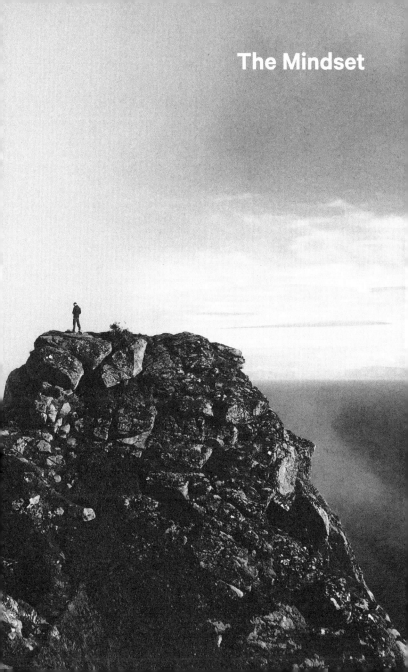

The Mindset

7

The troubled man and the mountain

The great master of martial arts Morihei Ueshiba became deeply troubled as to his true defining purpose. So he retired into the mountains with a Zen philosopher to reflect upon his work and life. He gave up the practice of martial arts as a form of violence and created the graceful non-violent martial art of Aikido – which is known for bringing calm, peace and strength to its practitioners.

Everything we do is shaped and guided by what we believe, whether we notice it or not. It is easy to dismiss the notion of needing a guiding philosophy, just as you might shrug off the idea of beauty as being nothing more relevant to our world than decoration. But without a guiding philosophy, we end up stripping away our navigational compass and losing sight first of our humanity, then our potential.

We need precision in our design and engineering, we need to know things are going to fit together, we need to have reliable repetition of making stuff. But these can't give us a why. Why do we do what we do? What purpose do we serve and to whom?

The great stillness

Tibetan calligrapher Tashi Mannox describes how over many years he hand-copied ancient Tibetan texts page by page; the standard of the calligraphy had to be extremely high. Sometimes it could take a year to finish an entire text.

He noticed that if he had any emotion inside it would be reflected in his calligraphy. Because of this it measured his state of mind. He realised that he needed a clear mind and clear emotion to draw and execute well from the beginning to the end of his work. We draw our most potent creativity from deep wells. That is not to say we cannot exercise energy as we execute. But we often mistake time pressures, stress and deadlines, alongside the cacophony of an always-on world, as the necessary stimuli to create great work. I believe great work comes from a place of stillness where one's focus is total on the action in hand, directed fully by the heart. This is what the Shakers did, and what we see others do generations later, when their tools are mostly digital.

To bring great stillness into one's work means one can truly commit to its execution and most beautiful realisation. It is commitment, Tashi says, that gives you freedom.

A quest for truth is always core to the purpose of a poet

The poet Seamus Heaney was a master craftsman of the English language. He embodied the other important characteristics of craftsmanship: a granite-like integrity and a deep empathy for the world around him. A quest for truth is always core to the purpose of a poet, to seek that which others do not see and to express it in a way that we can all understand. We often ignore the importance of language: its ability to uplift us, or to shape the way we see and therefore act in the world. Heaney wrote:

> '*What always will be to poetry's credit, is the power to persuade that vulnerable part of our consciousness of its rightness in spite of the evidence of wrongness around it.*'

As a poet Heaney wrote about life – his life experiences, and a very difficult present – compassionately. He would bring us into his world via the everyday; it could be the smallest detail of life, then he would expand into its broader context, always finding a truth at a universal level we could all resonate with. Whether that was describing how he folded freshly laundered aired sheets

with his mother, or exploring the human consequences of Northern Ireland's Troubles, it was all about 'the mass and majesty of the world'.

Heaney demonstrated that people can be graceful under any circumstances, wherever they stand or go. Heaney was more than a poet: he was a man applying his craft to truth.

It is in truth that we find beautiful things, and it is in truth that we can operate authentically. One might have the head of an engineer, but one must always quest with the heart of a poet.

Reality is full of depth of field

Sebastião Salgado, the celebrated photographer, said, 'Reality is full of depth of field.' He describes filling his images with volumes of great and intricate detail – that is the technical bit. It is what he sees, or chooses to see, that makes his work both unique and profound. Put 20 photographers in the same place and you will get 20 different versions, if not visions, of the world. It is a question of what we choose to see.

For most of his life Sebastião has lived alongside and within communities, tribes and environments so far from our world we could not know them. These people exist on what we might call the periphery of life. He sees the essence of souls, of where they live, never judging, simply interpreting their world for us. The recent film *The Salt of the Earth* is a documentary about his life's work that, poetically, viscerally, draws us into how he arrives at his own unique depth of field. It is nothing less than a masterclass in seeing as a human being. His description of a gold mine in Brazil – which has become perhaps one of his most iconic images – slackens the jaw in awe as he describes how his sense of what he experienced informed the images he took.

Consider, how do we learn to see that which currently does not exist to us?

How can we prepare to learn to create depth to our creative vision, so that when the moment arrives we can both see and take action to realise its full potential, filling it with volumes of meaning, resonance, information and context?

We need to open our senses to all that surrounds us, to simply absorb new information, challenging ourselves to be able to arrive at a new way of looking at, seeing and then understanding the world. It could be an ideological worldview, a form of artistic practice. It is an observational practice. It is more importantly an intuitive practice: by removing the distance between subject and observer, empathy gifts us a huge depth of field. It allows us to create works of great truth and great beauty.

The curious mind is the wellspring of creativity

John Steinbeck wrote in *East of Eden*, 'The free, exploring mind of the individual human is the most valuable thing in the world.'

Curiosity doesn't like rules, or, at least, it assumes that all rules are provisional. It rejects the approved pathways, preferring diversions, unplanned excursions, impulsive left turns. Curiosity is voracious – the more you know the more you want to know; the more connections you make between the different bits of knowledge; the more ideas you have. Which is why curiosity is really the wellspring of creativity.

If you really push your curiosity you will find yourself as Galileo, Charles Darwin and Steve Jobs did, rubbing up against fixed orthodoxies that asserted their regal, legal, political or religious authority trying to stop these disruptors' momentum and more importantly devalue their newly acquired authority. Not that these three adventurers did too badly out of it ... eventually. They brought beauty and a more beautiful way of being, and knowing, to the world.

To be and to remain deeply intensely curious about our world is vital to original thinking, whereas the incurious face a rather dim future. To have a hungry heart and mind determines what it is we create.

Try making an appointment with serendipity

Have you ever received an invitation from serendipity in the post or via email? It says, 'Dear xxx, I hope you are well? I would love to invite you to a moment of profound serendipity, say this Friday coming. We can have a lovely lunch and chat about those amazing insights I am going to give you. Don't be late. Love, Serendipity.'

No, serendipity never makes an appointment – she just arrives, in whatever fashion is her wont. She might jab the hand of God through the clouds, or she might decide the smallest, quietest whisper is all that is needed to nudge you along and reveal the insights you already hold.

So always leave the door open for a little serendipity, because you never know when it will turn up, unannounced. With your depth of field and curious soul, allowing something to evolve or to see meaning in playful accidents can make the difference between creating the same old thing, or something that is unique, valuable, lasting, beautiful.

Sometimes it's better not to try at all; just let things come. Only be ready to surrender your heart to serendipity's will.

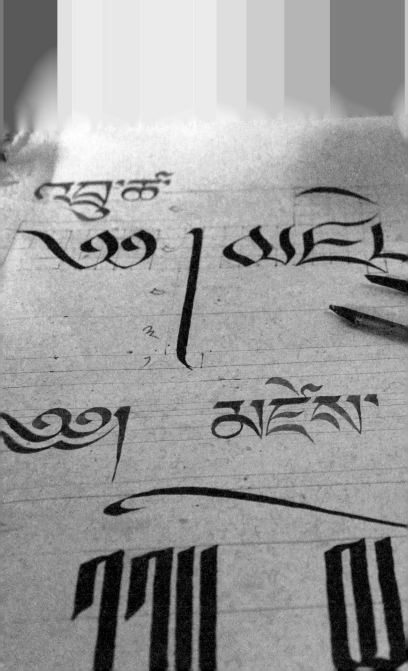

13

The Bill Bailey principle
for making the new

The comedian Bill Bailey was once asked how he came up with his jokes? Bill replied, 'I start with a laugh and work backwards from there. What do I need to do to create this amount of laughter?'

Bailey captures a truth about creating the new; about how we take a fiction and turn it into reality.

When presented with a design challenge, a designer makes a leap to arrive at a visualisation of what the best possible design/outcome looks like. For many this is an impossible way of working. How can you have clear sight of something that is unattainable? But the designer is comfortable that they can find a way of pushing the boundaries of tools, technologies, people's skills, to create that which previously did not exist.

Co-founder of Pixar Ed Catmull said, 'The greatest enemy of creative success is the attempt to fortify against failure.' If you want to create the future, the new, and the better ... you are going to make some glorious mistakes, graze your knees, and feel a little downhearted. But this is the process we all go through to get to create the truly valuable and original.

14

Tools to craft beautiful things

A young girl stands in front of a cabinet in a museum. The vitrine holds a collection of tools elegantly laid out, making their own pattern.

These tools are worn. They carry a lustrous patina only made possible by years of patient labour. There are many tools here and the craftsman would have been master of them all. He or she would have used these tools with great care. They represent a lifetime of making things.

The tools would have defined how a craftsman worked – shaping the working day, even a working life. Now these tools take their eternal rest, their working day is done. Their only function now is for us to gaze at them and reflect.

How you pick up a tool will shape how you use it and what you make with it. Pick up a tool with truth and beauty in your heart, work with positive energy and optimism. Then observe the results.

New tools allow us to make new things. They reshape how we assert the future, ultimately reshaping our lives, our economies and society.

Start with the space between the lines

Typography and book design is a craft of intricate detail. Everything can be specified and adjusted: the paper; its weight, colour, opacity, texture; the typeface, including the space between letters and line length; how the final design floats on white space. It is the control of the white space that can make reading a book a pleasant experience or otherwise. And we have not even started to discuss binding.

One day I asked one of the great typographers and book designers how he started the design of a book. He simply said, 'I start with the space between the lines.' Then he sent me out the door. I was perplexed, curious – what did it mean?

He was asking me to conceive the whole experience of the book, by thinking about its sensual, textured nature. How it could look effortless, and be a delight to behold. This design philosophy was also about the purpose of the work: the hand of the designer was in a sense hidden, no room for the ego of the celebrity designer.

We instinctively know when the design is right, and when it is horribly wrong. Cast your mind back to the harmonious Shaker chair. There should be a natural

resonance and rhythm, as the form blends content, images resonate with text, and text flows from one opening to the next with pleasing aesthetic logic. These things do not happen by themselves. They are the result of care, thought and meticulous attention to detail.

A former teacher, Derek Birdsall, RDI, used to tell me to design something to be inevitable. The implication: labour at your work until people cannot imagine what you have designed existing any other way. Beauty is work well resolved. It is simple.

The world is sensual and textured

Walk through the front door, smell the warm baking bread that makes a house a home. Feel the cold visceral shock of the ocean as the waves break on your body. Lie in a wild meadow and watch the clouds scud across the sky. Slowly breathe in the scent of summer rain. Pull on your favourite jumper, feel how you enjoy its softness. Take a walk through a wood, listen to the sounds and sense the endless shades of green, witness the shapes of the trees.

What's it like to be in a jazz club in Paris, a rave in Bucharest, or taking in a view from the highest mountain you have climbed?

When we are making anything we should never forget that as human beings we endlessly engage with our world through our senses. Our bodies are constantly computing all: temperature, pressure, wind, light, taste, sound, it goes on and on and on, all at the same time. Our intuitive consciousness is plumbed into all our senses. Sense and sensations pour into us 24 hours a day. It is how we make sense of the world.

Why does art endure? Because it always one way or another speaks directly to our senses. To design for the

senses is not weakness but strength. It resists the belief that making a business succeed is only about numerical measurement, the quest for efficiency rather than truth found in experience. Who cares? Well, we do, human beings do – the people that use your products and services.

Watch a two-year-old play with a touch screen designed for the intuitive sensual design of human fingers. Walk into a local food store and smell the produce, enjoy the texture and warmth of the store. Delight in the astonishing costumes of your children's school play. Know that it is the great authentic food cooked and delivered with loving care that keeps the local restaurant always busy seven days a week.

The interface with design is humanity. Success is when we make a universal cultural contribution – scale that as you like.

Great design is when you design for others to feel, to experience with their senses, perhaps even to be pleasantly surprised – a joyful experience. This joyfulness converts always into goodwill, warm memories and, if you are so inclined, cash. Some of the most successful recent businesses were founded by designers – adopting their practices could be the best thing you do for your business. We don't think beauty – we feel it, we sense it, we know it.

The master of materials

Jony Ive is the world's most well-known industrial designer; his work at Apple has redefined much about what we think about computers, and how we use them. To get there Jony and his team have become masters of materials and engineering production, pushing past the conventional, constantly asking 'Why not?' and 'How can we?' This is where, for many of us, engineering and production will say, 'No', 'It can't be done', 'You shall not pass' – that type of thing.

Ive and his team ask: Why can't we have glass, and glass this thin? Why not milled aluminium? Why can't the back of an iPod or iPhone be hand-polished? Why not a unibody? Why can't the insides be as beautiful as the outside? Why is that tolerance acceptable? If you can't make it – who can? In asking those types of questions, refusing the pat answers, Apple has become one of the richest companies in the world, delighting the owners of its products on a daily basis. As Emerson observed, great beauty is foundational.

Design is based upon resolving how someone is going to use something. Great design is describing the very best experience for them, then moving towards that ideal.

Sometimes that requires some spit, grunt and a refusal to accept 'It can't be done' as the only answer.

Finding the right materials and being able to apply them in service to a vision is fundamental to creating beautiful things.

Think about a sheet of paper – in the hands of some it can fail even to become a simple paper aeroplane that can fly. In the hands of others, it is transformed into the most deliciously delicate shapes by a process called origami; we can only sit in wonder at its magical beauty.

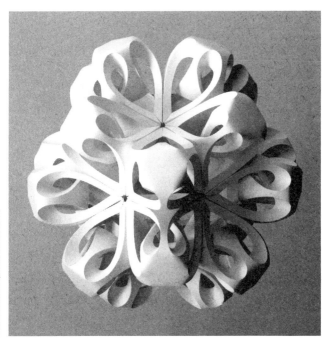

© Richard Sweeney, 2006, *Icosahedron II*

Fourteen practices
to create enduring beauty

Because beauty and great design appear
to be so effortless, we mistake it to be
easy. Or, that genius was bestowed
upon its creators by some divine spirit.
There is no doubt we all have gifts.
But it is only when we practise daily
that we develop the capacity to see,
design and create work we can be proud
of – that delivers something useful to
the world. Here are 14 practices that
I recommend using in an effort to
create good work.

Be curious about the world

Walking with my dog Piper through the countryside late in the year, I stop and wonder at the sheer beauty of a wood ablaze with autumnal colours, lit by the sun. I try on these walks to let my mind be still, like a pebble dropping to the bottom of a riverbed, and let my senses feel the world around me. It is the preparation to letting other thoughts and ideas come.

I stop at a coffee shop in Cambridge; my gaze takes in everything through my senses. I can see, smell and feel the love, the craft that has gone into every aspect of this business. And that is why this place thrives. Every time I go in there it delights me. I have been observing the world like this since I can remember. You might describe it as a gently persistent 'why?', a constant questioning.

Walking, or driving, I look at buildings – their shape, contours, how they sit in the land – old and new. I look at the brickwork of a house enjoying its texture, its warm red colour, and the white mortar. I stop at a church and let the stillness be in me for five minutes. I run my hand on a handrail enjoying its shape and visual appearance.

People fascinate me: how they move, how they dress, how they use technology. As I am reading about some new technological advance, a reflection comes to me.

Maybe I make a note or two in my notebook. It reminds me of something I was reading in a book. I put some notes in the margin to dig out the book when I get back.

I always have a book on the go, and I often annotate, underline, pull out stuff that intrigues me, inspires me, resonates. This process of writing helps me see more. Making connections, creating meaning, adjusting my world view.

I don't need to draw conclusions, I am happy for the thoughts to be half-formed but present. Reading widely on science, technology, society, economics, culture, is the raw material that feeds my imagination. This information stays with you, and at some point you turn a corner and you get an 'Aha' moment of deeper understanding. You see a new pattern – it is serendipitous. It is the subconscious mind that does all the hard work. You can't rush this stuff.

Increase your depth of field

When I am working on a new project, or running a workshop, I ask my colleagues this question. Can you develop a short thesis about something? For example, what are the near-term trends that over the next five years will change my life, my industry? Or, identify what we believe is a 'truth' about how the world works today and how it will work in the future. This I find is a very useful practice for oneself and for a group starting on a journey of discovery, whatever that may be.

I think it is important to recognise one's own limiting beliefs and question them. They stop you seeing. We all carry the baggage of our history: parents, school, upbringing and so on. Be aware of their limiting power to create depth of field. Learn to let go. Acceptance is a powerful tool in learning to embrace new possibilities. It is when we resist – emotionally, intellectually, spiritually, because our expectations or beliefs are not met – that we break, and we do not learn. We have to learn to let go.

Don't overlook the simple. We have a tendency to complicate things. 'Feel' is an important filtering system towards truth.

Develop an ability to adapt

We have to be prepared to continually upgrade ourselves, our business models, ways of working – and we can only do this if we learn to become agile. Adaptiveness is based upon a continual process of creating, collaborating, communicating and critiquing. It is a practice that evolves a new literacy of thinking and doing because, if we cannot describe a new destination, we will never be able to get there.

Observe

Look at other companies. Ask yourself – how do they work? What makes Patagonia so successful? Why is Amazon so popular?

Can you list all of the things Amazon does that has enabled it to become the singular most powerful online retailer?

For my part, I like to build what I call a 'pattern language' of how that company broadly works. This can reveal our own blind spots and gaps in knowledge, suggesting new design possibilities. Everything is made up of component parts.

Why is the restaurant The Fat Duck so loved and therefore so successful? You might only be working on a street food project, but always steal from the best. Look at things, take them apart and explore how one could create them differently.

Go See

Meet other companies, or people that you like who inspire you. It might be their product design, or courage to defy the odds, technological prowess, an ability to tell a story that is so compelling it makes you cry. People love talking about themselves, and you will learn a great deal.

I was intrigued by Yeo Valley Farms, how they transformed themselves as a business. So I picked up the phone to Tim Mead and asked if I could come and visit. He invited me down to Yeo Valley, and I spent a day getting a lesson in large-scale organic farming. There was no reason why Tim, a busy man, would want to spend time with me. Maybe it was because I asked nicely.

Derek Birdsall was another person I asked if I could meet. This great designer liked my attitude and took me under his wing. You just never know what happens with a Go See.

Understand language

I have a thing about language, words that describe a process, or a new technology, or an idea. By constantly evolving our language and knowledge we are constantly upgrading ourselves and our capacity to create and design better things. This is how one works in a multi-disciplinary fashion. Being able to cross over from an idea to how to make it, and describe it to someone else. Having knowledge, even a basic understanding of new ways of working and making, enables us to boost our creativity.

Be open

The concept and practice of openness is foundational to creating enduring beauty. Nature's default setting is open. It is regenerative and restorative, and so should we be. Openness is a design tool offering new organisational, social and commercial capability. Openness is cultural – being open to new ideas. Openness is mutual – the sharing and redistribution of knowledge, information, data resources and wealth.

It is inclusive by design, and it fosters social cohesion. Openness as a principle and practice offers boundless opportunities: new capabilities through open platforms; higher organisational performance, as open innovation accelerates R&D and reduces costs; trading models; open-source software; and legal frameworks such as Creative Commons.

Always be open to new ideas, new thinking, new tools and technologies.

Pixar, from the early days, shared their technological innovation. Today they share openly how they work. Elon Musk gave away the patents for his battery technology as a means to stimulate the growth of the electric car industry.

Does openness challenge your belief system, and if so why?

Work better together

Over the years, one of the things I have learned is that we as human beings are designed to work in aggregate. Collaborative endeavour has defined our species. There are many benefits, including opportunities for peer-to-peer learning, not to mention the empowerment of a people working more effectively together.

The practice of working collaboratively is key to successful outcomes. We need to learn how and why we collaborate, what motivates human beings to give their creative best. I have witnessed its practice in many environments and if it works for anything from a public health authority to a billion dollar company, I believe it can work for you.

My own mantra of 'people embrace what they create' is how I teach and how I help people see they have the tools to be masters of their own destiny. Why not explore collaborative practices in leadership, creative endeavour, and personal development? There are links at the end of the book for where you can go to find more information. To be clear, collaborative practices are not some hippy free for all. They are the very essence of all that makes our societies and communities work well. My only other hard learnt lesson is you have to 'do' this stuff to understand how it works.

Start with optimism

Where do we start any piece of work?

We want to be inspired, to be excited about the creative potential of making something useful. It could be a new piece of personal work, it might be a business challenge, but key is to be intrigued enough to lean forward and give it your attention. Start with really wanting to bring something good into the world. You need to feel optimistic so that infuses the work.

Write the narrative of what a best possible outcome looks like. What does it feel like? How is it helping people in their lives? How does it give them joy and delight? How can this piece of work bring value to the world? Then ask yourself how you might get to that destination. What I find is that if we start with why we can't do something, we tend not to find the means to overcome that challenge – we are defeated before we have even begun.

Whereas when one believes with conviction that this design is the right one, all the other stuff becomes simply logistics to be dealt with.

Recognise no boundaries

There are no boundaries to what you can see, what you can make, how you make it. The only questions you need to ask yourself are why, and can it be beautiful?

Many years ago, I wanted to make pictures. I don't know why, but I had a yearning to create and make, but how? I could neither draw nor paint, yet I loved painting and I loved photography. I wanted it to be visceral – so how to make visual works that were my own?

My early work as an artist accidentally brought together printing and imaging (Xerox) technologies that previously had not rubbed shoulders, shared pixels or mixed together with inks and paint. I had no money but I had hired a photocopier. So I found a way to get these different technologies to talk to each other. I made it up as I went along. I had no idea these production technologies had not been combined before, but it worked for me and in some respects there was a beauty in that too.

Using the photocopier as a tool, I learned how to stop the machine before it heat-sealed the copy I was making. I could then edit the unfixed image with brushes and pens, and my hands. I would chop up an A3 image into four and then enlarge each back to A3. I would create layers of tone, building up the image by rephotocopying the base image

while introducing new elements. Ultimately I created photocopy prints that were six feet by four feet.

The large photocopy images became the basis of a commission to make 12 images that were printed by master printer Kip Gresham. Again we deconstructed the images and rebuilt them by scanning and then printing. I even wrote a poem for each image. Was this allowed? Of course it was. There are no rules, only the ones you make.

Recently, Kip and I shared our insights that in 1987, together, we pioneered a new way to make images.

Latterly my work has been more in the digital realm, where I am fascinated by new ways of connecting and communicating, building businesses that can create more value, be disruptive if necessary. No one knows what these look like. So you have to see if it works out. If it doesn't, it's a prototype – there is always learning.

Recently I came across a company, Solidwool, that makes chairs and tables from Herdwick sheep wool. Beautifully unique, I love what they do and am intrigued by how they came to make these things of great simplicity, beauty and utility. Guess what? I am on my way to a Go See.

Surrender

One summer morning I woke up at 5 a.m. Looking out the window there was a dense fog that had majestically draped itself over the landscape. In that instance an image formed in my mind of a bridge over the River Ouse near where I lived. I saw the image and surrendered to its creative call.

I jumped in the car and drove the few minutes to the river and the bridge, taking several images in about half an hour. Even though it felt spontaneous at the time, curiosity had led me to the river in the weeks leading up to this moment. My camera was loaded with film and I had some spare. All I had to do was go.

The images taken that day formed part of a solo exhibition. Fifteen years later those images live on someone's wall.

We should be prepared to surrender to our deep intuition. It comes with looking, observing, thinking, reflecting and practice. This is our preparation.

See 'Ouse Bridge' photograph p. 46.

Only work with good people

We all learn the very hard way, but trust your instinct.
Do not work with people who don't want beautiful, who
wish to cut corners to increase profitability. Who, more
dangerously, bring neither elegance nor grace to their
work and their working environment, but the opposite.
Work should be enjoyable and should uplift your spirits
as it did the Shakers. Our time on this planet is short,
so make it count.

Let go of fear

I can look back now on a career, halfway done. And I can say you do not make the best or wisest decisions when you are filled with fear. You don't make your best work either.

My practice is learning to let that fear go. This is easy to say but very hard to do. You have to really believe in what you are doing, you have to work with conviction. You have to be able to back yourself.

I did not ask the permission of anyone when I decided I would teach myself all the creative and craft skills I did. Of course we all worry about being 'good enough', but that should never stop us trying our best. Sometimes even now I look back and wonder at my audacity, as you were supposed to have lots of qualifications and certificates to prove you were good at this, when in fact I had not a single one.

I have travelled six continents, overseen and directed some £1.5bn of creative business innovation. I've had my personal work shown and displayed from London to New Zealand. And I've written a few books. I am dyslexic and I hate flying.

Seek to create enduring beauty

As we collectively face real and significant challenges, we shouldn't adopt a state that seeks incremental change: we must create and design better things.

It is about recognising the opportunities for creating the new and having the courage and the conviction to blend new and old tools, processes and language together to evolve fresh, novel and meaningful ways of making stuff. It demands innovation and the transformation of all the existing organisations, legal systems and economic frameworks that currently define our world. And sometimes, you just have to stand your ground.

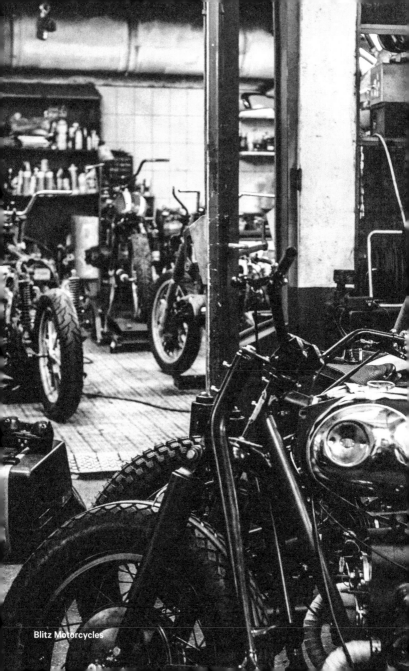

Blitz Motorcycles

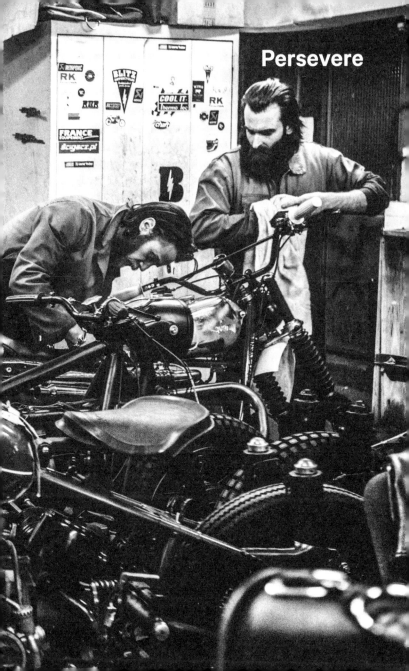

Persevere

The ballad of Willie Nelson

If you believe that our best work is done when we are young, you create a grey future. Every day is the opportunity for the new, as yesterday has now gone. Drawing from a bitter well is not good for creativity.

Willie Nelson has made 250 albums, and is still touring in his eighties. He did not get a break until he was 40. The author Mary Wesley was not published until she was 70 – she ended up being one of Britain's most successful novelists, selling 3 million copies of her books, including 10 bestsellers in the last 20 years of her life.

You can beat yourself up about not getting there soon enough, believing opportunity has passed you by. If that is what you believe, it is true.

Or you can believe that when success arrives it is the right time, and all before has been your preparation.

Shingle beach and John Donne paradise in a garden

On the last 100 metres of the English coast before it falls into the ocean is a garden of unique beauty. It exists in an inhospitable place. It's a garden that lives on the edge of the world. Nature is at her most ferocious – wind blasting the landscape, beating at the shore with salty fists, roasting everything with fiery sun, drowning the unwitting with relentless rain. There is no soil, just shingle that strips skin from fingers. Creating a garden in such a landscape seemed … impossible.

On that beach is an old fisherman's clapboard hut restored by the artist, filmmaker, writer and poet Derek Jarman. Derek named it Prospect Cottage. On one side of the house Jarman had put up John Donne's most famous poem about love, and belonging, 'The Sun Rising'. It was here that he created and planted his garden of gorse, sea kale, santolina and wild flowers, organised around the found flotsam of a beachcomber-cum-artist.

In his book *Derek Jarman's Garden*, he ignites our senses like flints to tinder. He sparks our imaginations to create something not only from meagre means, but something of great beauty. He invites us to smell the salt and the wild flowers, to listen to the old wooden

hut creaking as if to burst under a heavy gale, to feel the warmth of the sun upon the shingle as the soporific hum of a bee plays in the background, to marvel at the sheer resilience of the plants that thrive here – weaving as he does a magical spell.

I treasure his book because Jarman lifts us up with his spirit of creative optimism, more potent because he knew he was dying. I have gardened for over 30 years and know what it means to commit to a bare patch of land, turning it into its own form of paradise.

Jarman wrote that 'paradise haunts gardens and some gardens are paradises. Mine is one of them'.

We all have a shingle beach. How can we make it beautiful?

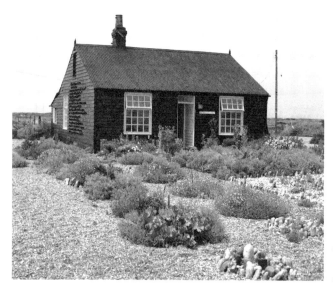

Prospect Cottage

Time is earthed

The garden that I have been tending for the last two decades is magnificent. In the summer when the sun is up and the wind calm, it is its own timeless paradise.

Down one side is a long beech hedge, several metres high. Twenty years ago there were just twigs in the ground struggling to survive for lack of water. For a whole summer I relentlessly carried pails of water to quench the thirst of these young plants. We had no hosepipe that could reach to the end of the garden.

Over a few years some of the beech died, leaving big gaps. Standing one day with my father-in-law, I suggested we buy replacements the same height as the existing hedge. My logic: speed, ease, money. No problem. He gave me an old-fashioned look. Narrowing his eyes, he sighed and shook his head, saying, 'It's the roots you need to be concerned about. Not its height. If you want a beautiful hedge invest in good roots, don't go for a quick fix. Your way would mean most of the plants you bought would die.'

So we bought small plants with strong roots. Today it is a magnificent hedge – bronzed for the autumn and winter months, deep lush green for spring and summer. Some things can take the time they need. Not the time you think they need. Time, like the hedge, is earthed.

Love the work you do:
Blitz Motorcycles

Hugo and Fred build motorcycles. They build them from discarded older motorbikes, curating their builds using the frames, engines, petrol tanks and handlebars from machines of another time. They call their company Blitz – as in giving new life, new energy, new purpose, to old motorcycles.

Possessed with an aesthetic vision of how these motorcycles could be reclaimed, then reborn as something new and exciting to ride, Hugo and Fred laboured after their love. For them, motorcycles, and motorcycle mechanics, are a passion. The preservation of a time of motorcycle engineering became their quest. Kick-started from the place that makes the heart beat a little faster – the sound motorcycles make, the way they feel riding through Parisian streets or through the dusty back roads of another country – wherever they are, Blitz motorcycles speak to the soul. If the existentialist poet Thom Gunn was alive today his poetry would thrum to an engine hanging in the heat of a Blitz motorcycle and the leather-jacketed riders directing their trajectory forwards.

Hugo and Fred taught themselves about motorcycle mechanics, learning through trial and error. It took a little

time, as it always does to become a master of your craft. They persevered, knowing that time is earthed. You can't rush to greatness, you can't guarantee it – you can only work towards it by practising your craft every day, directed by your passion, by your purpose.

Sacrifice can involve money, and time doing other things, but that all adds up to realising a purpose which gives much greater rewards. The reordering of happiness, work and play. Hugo and Fred speak of working joyfully together, they speak of the joy of continuously learning. Surely this is the true mark of the pursuit of craftsmanship, the revelation of beauty and its rewards. And they speak of taking an autonomous position, a place where one can live and work without debt and the many life challenges debt can create.

Simply, these machines take time to build, as each one is unique; there are no timesheets, only love as the arbiter of good work and a day's toil. Fred and Hugo say they have met more interesting people in the few years they have been working as Blitz than in the previous ten years: 'They are more interesting, because they have a passion like us.' They treasure every day.

Watch people who love what they do. Feel their passion. Listen to how they describe their work.

Investing in loving what you do always costs time, money, and sometimes the odd scar and bruise. It repays that love with personal satisfaction, and in turn it inspires, guides and nurtures the spirit in others.

If we invested in more things that give us a meaningful life, our world might feel a little different. And our work might even outlive us.

As a good friend said to me, 'Invest in love, it pays well in the end.'

Connect

The beauty in leadership

We must all have our own standards as individuals: never satisfied, always questioning. This is my personal practice. We as leaders must always be a work in progress, quietly getting on with that work. Never lose sight or empathy for the people you lead. Leading with empathy, and humility to be in service to all, is key to great leadership. You may have a vision, and a destination you believe in, and your hard work has enabled you to believe this destination to be real and necessary. But if you depend on the souls of others to collectively work towards that goal they too must believe it to be true; they must believe in you and your purpose.

The danger for the leader comes if you cannot truly love yourself. If you are at war with yourself then you will be unable to lead others with empathy and compassion. You may pretend – but you will always be found out.

A leader's real authority is a power voluntarily given by others. It is an optimistic gift in the belief that power will not be abused and things will be better. To earn this gift, one never asks for it, nor expects it. One can only lead by example.

On the other hand, it is the soft skills of listening openly, making time, helping, being honest, and creating moments of opportunity where the individual and collective hand, heart and mind can begin to build the new. And it just may be they are better at it collectively than you. Allowing people to arrive at their own conclusions of what needs to be done, and embracing what they create, is another form of wise leadership.

I was once tasked with working with a state broadcaster to redefine its purpose, brand and marketing to make it more relevant to its audience. I could see what needed to be done, and knew my team could deliver. But I also knew that in order to succeed, we needed to take the people who worked there with us – to make them part of the process of transformation, from start to finish, because otherwise they would not own the outcome and all the hard work and money spent would be wasted.

Over a period of one year I got the entire organisation co-creating to develop a shared vision. Then I set projects, inviting people as individuals and teams to become responsible for delivering on certain tasks blending them with the team I had assembled. I followed the rules outlined above: listening, creating dialogue, becoming part of a team. My job as I saw it was to make them believe they could be better as individuals and as a collective. What people saw was genuine commitment to create something new. No one was special, and hierarchy was flattened. I made sure everyone had a heart connection to this work – that they took pride in their work and were recognised collectively for their commitment.

At times it was not easy – co-creating stuff produces difficult conversations, though as I saw it this can be the binding material that forges a collective will to create great work.

People embrace what they create

People embrace what they create with love, with energy, with passion. They are prepared to go the extra mile. Their work becomes a labour of love – for we as people do not labour for monetary reward, we labour for meaning.

So whether leading a team, or running a workshop, ensure people are the true co-creators of their future, that they are heard and listened to. That is a very different energy and motivation from barking orders and telling people what to do. And you'll probably find people are less stressed, take fewer days off work, and the workplace becomes a cultural hub of vibrancy and energy.

When people are co-creators they become part of a narrative that runs through a business. They become part of its story.

As French writer Saint-Exupéry put it, 'If you want to build a ship, don't give out orders and tell people exactly what to do. Teach them to yearn for the vast and endless sea.' The rest, I believe, will take care of itself.

I am all for helping others yearn for the vast and endless sea.

Muhammad Ali's best poem

Muhammad Ali was once asked what his shortest poem was. He replied in two words: 'Me, We'. In these two short words Ali gave insight into our true human nature. We need to be truly ourselves as individuals, but we can only be so when connected to a greater 'We'. The Me needs the We to create more than is possible as an individual; and the We needs Me – every Me – to come with their full capacity to create meaning collectively.

'We' is how we create narrative, culture, context and meaning – it's the glue that binds us. Strip a community or a business of the means to create We, and we all suffer as a result.

For a while we forgot the We, and got hung up on the Me, Me, Me, a bit too much.

But if you want vibrancy in your business, vibrancy in your community, I would read Ali's shortest, and perhaps his best, poem again and again and again until it becomes a mantra.

Nurturing beauty together

We all know the extremely successful film company Pixar. Their films are great not only because they are masterpieces of animation but because they tell compelling stories.

But this is not easy. After the runaway success of *Toy Story*, Ed Catmull and his team agreed there had to be a way of openly and tenderly holding a creative idea so that it could evolve to its true potential of excellence every time. To do this required the idea to be open to close scrutiny in every aspect of its script, design and production. It was for this reason that the Braintrust was created.

In a large room, members of Pixar regularly come together to openly test the development of a film. The rules are: only constructive criticism, and to speak with candour. It requires great trust to do this, to speak plainly and honestly and for the director to listen to all feedback. Without trust there can be no creative collaboration. The focus is on solving a problem. Individual knowledge becomes a collective intelligence, highly valuable in examining how one gets from mediocre to world class. Catmull believes every movie they start with sucks in the beginning. In his words, meetings are filled with 'frank talk,

spirited debate, laughter and love'; they are there to excavate the truth in a movie.

The other rule is that the director is never instructed to do something. The director listens and develops his or her own interpretation and understanding of feedback given.

It is unusual for a creative company, or any company, to work so rigorously in an open, collaborative environment. It takes patience and time – something Pixar are willing to give. To create enduring beauty requires intense collaboration between people who share the purpose of creating something truly unique. Anyone, therefore, no matter in which industry they work, can create their own Braintrust. It might just get you from mediocre to great.

Aspire

Salva Corpus Amanti and
a bit of joined-up thinking

In the late 1980s Gerhard Richter had a show of abstract oil paintings. These were made by layering slabs of different-coloured oil paints over each other, then dragging a silk screen squeegee across them; in so doing he revealed an abstract image.

These images carried no specific form, though to me they manifested themselves as waterfalls – powerful, majestic, transcendental. You stand in front of these paintings breathing in the intoxicating smell of oil and turpentine. It feels as though they have come from another world.

It is the unresolved nature of abstract painting that is its true authority. The idea that truth is subjective is its root. It is also the foundation of modern physics.

Travel writer Robert MacFarlane states: 'Natural forces – wild energies – often have the capacity to frustrate representation. Our most precise descriptive language, mathematics, cannot fully account for or predict the flow of water down a stream, or the movements of a glacier, or the turbulent rush of wind across uplands. Such actions behave in such ways that they are chaotic: they operate to feedback systems of unresolvable delicacy and intricacy.'

We can see the connectedness in things and appreciate the nature, and beauty, of an interconnected world. So where does that take us? What are the implications for beauty and design and what you and I might make with our hands, hearts and minds?

Reflect on Edgar Mitchell's ever-so-poetic use of the phrase *salva corpus amanti*. If we want to thrive on this planet, we must see our world as an interconnected whole – we have to 'save the lover's body'. We need to understand that humanity is a living system too, deeply interconnected with nature's systems. We all ride flows of matter, energy and information. So it is absurd to persist in refusing to see our world as being interconnected, attempting to describe it instead as a place to be managed like numbers on an Excel spreadsheet, devoid of meaning, context, community and history. This could be our downfall.

How can we get to creating a world that feels a little more beautiful? The world that all those astronauts realised was the right one as they experienced their *salva corpus amanti*? The answer: We need to think about the purpose of the work we do and how we serve to create a more restorative life – whatever that looks like. We need to dedicate ourselves to becoming craftspeople, strong in ourselves, innately curious about the world we live in and how we can contribute to making it better.

Everything we touch as human beings is designed. We consider purpose, form, function, aesthetics, manufacture. And if we have to do it every day, why not follow William Morris's maxim: Have nothing in your house that is neither useful nor beautiful. And, as Tashi Mannox, Fred and Hugo from Blitz Motorcycles, or the people at Pixar show us: to be true to your purpose, to commit completely, brings great freedom and, it seems, joy too.

Living off the coast of Utopia

We can all live off the coast of Utopia. There it is, shimmering in all its perfect beauty across the water.

Of course, we can never get to Utopia, we can't achieve or create *perfection*. But that does not mean we should not try. Michelangelo's *David* comes pretty close. Conceiving then striving to create that which previously did not exist is the work that makes our world a better place.

The cynic dismisses the existence of Utopia, preferring the surety of mediocrity, and worse.

The wise person is optimistic, prepared for the reality they will not get to the Utopian shore, but keeping its possibility in their sights. Working this way offers a joyful and more meaningful existence. It is a continual process and that is its enduring beauty.

No pessimist ever discovered the secrets of the stars, or sailed to an uncharted land, or opened a new heaven to the human spirit. As you sail along, maybe it's wise to keep the Utopian coast in your sights.

This is what *Do Design* is all about. Navigating towards ways in which we can design with optimism to uplift our humanity and our planet. The more I think about it, the idea of beauty living in everything would quite naturally create a more restorative world.

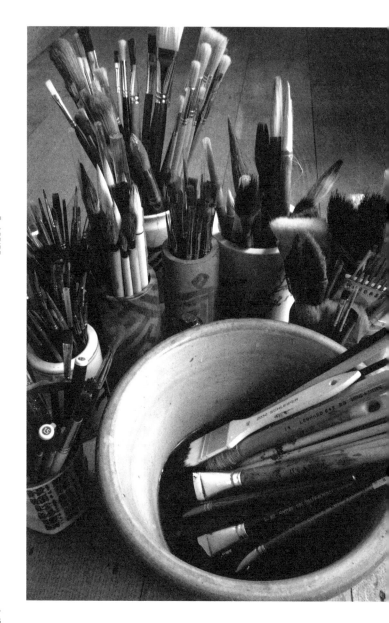

The philosophy of 'ing

Playing

Making

Loving

Baking

Coding

Inventing

Crafting

Painting

Stitching

Weaving

Meditating

Banging

Sawing

Reflecting

Laughing

Drawing

Exploring

Forging

Blowing

Sowing

Dreaming

Printing

Sharing

Inspiring

Guiding

ASPIRE

What is your 'ing?

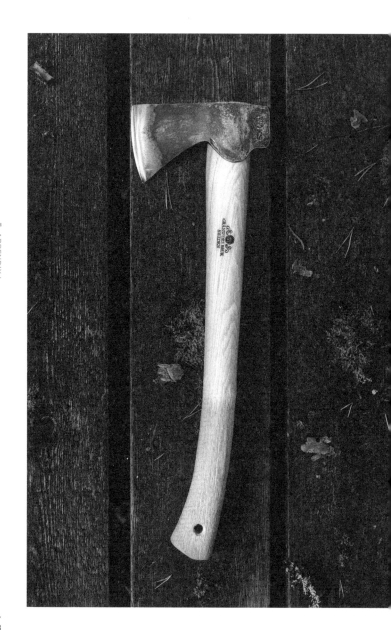

Appendix I

Gränsfors Bruk: How to design and create a beautiful business

Gabriel Branby is chief executive of Gränsfors Bruk, a company that makes axes. His story starts with him buying Gränsfors Bruk. Discovering the company was in financial crisis, he also realised that the inequitable way in which people were paid showed in personal motivation and the end quality of the product. So he sought to find a way that would bring his workforce together as a community, in which they all believed they were sharing equitably, married to a refined production process and an ethical approach to business.

Branby's story is about how one designs and builds a successful company predicated on quality. A quality of product achieved through a holistic approach to design, and manufacturing that incorporates a process to bring out of his workforce a commitment to craft and ethics. These craftspeople are able to produce the best axes in the world.

To do that Branby pursued the essence of the axe. He stripped it down to find its truth, took away unnecessary materials and production processes and added the right knowledge.

At his factory in Sweden, Branby has a collection of over 2,000 axe heads. Travelling extensively through his homeland and further afield, talking to people that

use axes on a daily basis, Branby gathered extensive information on the tools – their usage and design. That knowledge ultimately informed both the business design and the manufacturing process he employs today.

Responsibility for 'The Total'

Branby calls his worldview and philosophy 'The Total', as it encompasses ethics, business, production process, products and the world we inhabit. For him, 'What we take, what we make and what we waste' are in fact all questions of ethics. We have, he says, an unlimited responsibility for 'The Total', a responsibility that we try but do not always succeed in taking. One part of that responsibility is the quality of the product and how many years it will endure. Rather than designing in obsolescence, Branby designs it out.

This philosophy in making a high-quality sustainable product is a way to pay respect to the axe and its user, and to nature, which provides the raw material. A high-quality product in the hands of those who have learned how to use it and look after it will very likely be more durable. This is good for the owner, but it is also beneficial as part of a greater whole. Increased durability means that we take less (decreased consumption of material and energy), that we need to produce less (which gives us more time to do other things we think are important or enjoyable) and that we destroy less (so there is less waste).

Craftsmanship and making meaning

The team at Gränsfors Bruk are motivated to do good work. They are able to forge axes with such precision that no supplementary work is needed to stone, grind, smooth or paint the axes to hide mistakes in the forging. The forging

craft is allowed to take its time. The smiths do not work by the piece. They take care and do the right forging from the beginning. A smith at Gränsfors Bruk has nothing to hide and is proud of their professional standards. When the smith is satisfied with their work and has personally accepted the axe, the head is marked with their initials next to the company's crown.

There are lessons here to learn about innovation, seeking new ways to create. And this has been achieved through learning deeply about anything and everything to do with axes and stripping away all the things that gave nothing of value to the axe. Gabriel gave meaning to his workforce and a motivation in which they were commercially but equally personally dedicated to give their creative best – an engaged craftsman is a committed craftsman, ergo an engaged workforce is a committed workforce.

Meaning is created through a craft approach to life. And in many ways it is a gift that we give to ourselves and to others. So craftsmanship does not only exist in the manufacture of ancient tools; it exists, or should exist, in all that we do.

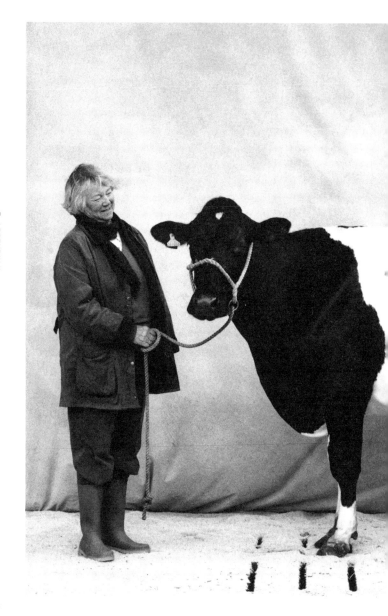

Appendix II

Yeo Valley Farms: Working with the beauty and power of nature

There comes a moment in one's company or industry when we are presented with an unexpected and uninvited challenge. The challenge is disruptive, momentous and complex – with no easy answer. There may be short cuts but these tend to be short term.

This is the story about how Tim Mead, the CEO and owner of Yeo Valley Farms, found a beautiful answer to an uninvited, yet fundamental question:

How do I keep my family farm in business?

Everything we face is a design challenge

Tim embraced this question and explored the problem as a design challenge. He asked himself, 'If the farm currently exists in an economy that is hurting us, how do we deal with that? How do we dream big and find the best answer we can?'

The answer was to go organic, to remove and reduce the impact of the volatile external forces over which they had no control – namely oil prices. Tim had to work out how to deal with such volatility, without being beholden to the power and whims of the major supermarkets, combined with fluctuations in the price of oil and its impact on the daily costs of running a farm from fuel to fertilisers.

So part of Tim's design challenge was independence: what did becoming master of one's own destiny look like?

Developing a narrative of a best possible future

Importantly Tim made his decision to go organic for rational economic reasons. Yet 25 years ago, when he came to this point of view, it was considered less unorthodox, and more heretical. Organic large-scale farms? From a mindset perspective it was a bold move, and it takes strong presence of mind and deep conviction to not be swayed by the in-vogue thinking of the day.

Developing a new narrative of how a farm could work at scale more resiliently, Tim had looked far ahead, identifying a pattern that made sense, even though the current ideology was to run farms like industrial machines. He sought the best possible long-term future for the farm. Yeo Valley encouraged more local farmers to become organic and form a co-operative, with a guarantee to buy their produce to cope with growing demand.

Quality of product and customer demand

Running a large farm organically requires some head-scratching from time to time, but Yeo Valley now produces the best milk in the UK. Tim reduced the cost of his inputs, and increased the quality and quantity of his outputs. He created a greater demand for a superior product.

The beauty of organic farming

To get the best out of nature, you need to respect nature. To do that one must understand it's a fine balancing act to deliver yield performance of a dairy herd and maintain

the land that supplies the nutrients to those cows. 'Push nature too hard,' says Tim, 'and she will bite you back.'

Tim believes cows perform best – producing greater quantities of better-quality milk – under certain conditions. The cows have room to roam, their diet consisting of clover-rich grass grown without the use of artificial fertilisers and pesticides. Wildlife is encouraged to flourish and conservation of the land extends to rebuilding limestone walling and replacing hedgerows. In an effort to reduce pollution and food miles, lorries transporting Yeo Valley yoghurts are double-deckers.

'Everybody who is a farmer deep down understands the balance of animals and nature and crops and rotations, and I think most farmers have an in-built sense of what is the right thing to do,' he says. Care for the land and the animals at Yeo Valley are a prime concern.

A co-operative business model

The farm and the business cannot run without people, so people count too, as a working community, especially since they work as a co-operative.

'When organic farmers were looking for somebody to buy their milk, we encouraged them to get together and promised to buy their milk for a period,' says Tim. Usually, manufacturers don't like it when farmers get together because they don't like the strength such collaboration gives them, but Tim encouraged organic milk farmers to set up the co-operative and promised support by giving them a guaranteed market. Yeo Valley Organic continues to take milk from around 100 OMSCo (The Organic Milk Suppliers Co-operative) farmers in the southwest to supplement the milk they produce on site.

For Mead, this is simply the logical way of running his business. 'If things are not in balance or sustainable then they aren't going to be there forever, are they?' he asks. 'I think most farmers feel that they have to take care of the land and what they are farming, and I think most of them feel, financially, it is difficult.' He points out that returns from farming average 1.5 to 2 per cent on capital over the last 50 years and blames a distorted market for this low return.

A values-based approach

Tim Mead believes in values: 'Maybe big is not always beautiful, maybe multi-nationals aren't always the answer. If you are just doing things for profit, who are you serving? The shareholders or the people who buy your products?' Yeo Valley represents an ethical framework and values-based approach to commercial and business practice, by asking, 'Is what we create for the collective good?'

Short-term thinking can leave you vulnerable

In contrast, Tim believes that those agricultural companies completely dependent on an oil-based economy are in fact unsustainable, and vulnerable to volatile global conditions. He believes that his overall operation – although organic farming does present its own unique challenges – is more enduring and economically viable. Nothing is wasted. It is also a fine balancing act between now, tomorrow and ten years' time, but this ever-present headache means Yeo Valley Organic constantly invests in its future by looking at the whole eco-system. It continually invests in the quality of its soil, its herd, its manufacturing capability and its people. One simply cannot be separated from the other.

1. See more, see further

Tim Mead was prepared to look towards the long-term future of the business. He developed a depth of field enabling him to see the underlying and connected forces that were financially hurting Yeo Valley by looking at the problem as a whole, then as a design challenge. 'What do I need to do to create the best possible outcome for the business?'

2. Adaptiveness

Tim was able to take that depth of field and evolve a thesis of how to evolve, what would work and why. From this vantage point he was able to make decisions where he could explore alternative narratives for Yeo Valley, and he never stops exploring. 'At Yeo Valley we have what we call Plan A,' he says. 'The A stands for Again – every time you turn a corner there is something new and you have to start all over again, so the plan changes every day.'

3. Openness is restorative

Yeo Valley has developed a thriving business by working with and respecting the diversity of nature. The company openly shares what it knows of how to farm organically and scale the business.

4. Community is everything

Yeo Valley works very hard with its local community; people and place are critically important. Yeo Valley Farms also does a great deal of educational work, bringing children and adults onto its land to share its knowledge, ways of working and philosophy. Its co-operative model of buying organic milk has proven to be highly effective.

5. Craftsmanship

Today Yeo Valley Organic is a much-loved company, with many awards for product quality and innovation, and a Queen's Award for Enterprise presented in 2001 for the revolutionary way it worked with its farming suppliers, encouraging them to turn organic and giving them long-term 'fair trade' contracts. The firm won another Queen's Award for Enterprise for Sustainable Development in 2006 for its approach to management with continuing support for sustainable UK organic farming.

6. Creating enduring beauty

Yeo Valley Farms went from a small farm going out of business into a company that dreamed big by keeping Utopia in its sights. It had the courage to turn fiction into reality, by understanding time is earthed. Consequently, Yeo Valley delivers healthy products, and is sustainably profitable. Its ways of farming are designed and crafted; everything is executed beautifully.

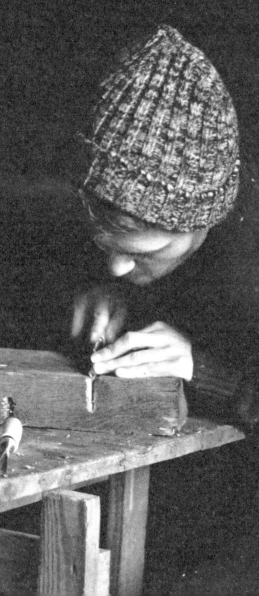

Resources

Resources

Websites

Blitz Motorcycles
blitz-motorcycles.com
The Do Lectures
thedolectures.com
Gränsfors Bruk
gransforsbruk.com/en
Kip Gresham
theprintstudio.co.uk
Shaker Workshops
shakerworkshops.com
Tashi Mannox
tashimannox.com
Yeo Valley Farms
yeovalley.co.uk

Go See

The Queen's Head, Newton, Cambridge
Hot Numbers, Cambridge
The Fat Duck, Bray
Derek Jarman's Garden, Dungeness
Iguassu Falls, Brazil
Someone that inspires you

Watch

The Salt of the Earth
Sabastião Salgado
Documentary

Read

Derek Jarman's Garden
Derek Jarman
Your True Home
Tich Nach Hanh
Creativity, Inc
Ed Catmull
The Craftsman
Richard Sennett
The Human Chain
Seamus Heaney
Dancing in the Streets
Barbara Ehreneich

Listen to

What a Wonderful World
Louis Armstrong
Ein Deutsches Requiem
Brahms
Are You Going With Me?
Pat Metheny
Summertime
Miles Davis
You Are So Beautiful
Joe Cocker

Collaborative learning

Johnnie Moore
johnniemoore.com
Tim Merry
timmerry.com

Quotes

*What you believe
you become.*
Buddha

*Every day surrender
the head to the heart.*
Buddhist saying

*When civilisations fall,
the only thing left is art.*
Anon

*Artistic expression is
not a luxury item. It is
a necessary item to
having a Civilization.*
Steven Galloway

*If you can't find
inspiration in everything,
then look again.*
Paul Smith

*Faster alone,
further together.*
African proverb

*Craftsmanship represents
the trinity of the hand,
the heart and the mind.*
Richard Sennett

*Man discovers things
by revealing the pattern
of nature.*
John Fowles

*Every tool carries with it
the spirit by which it has
been created.*
Werner Karl Heisenberg

*I dream my painting,
then I paint my dream.*
Elle Luna

*To create requires that
something can be envisioned
before it can be caused.*
Edward O. Wilson

About the Author

Alan Moore has designed and created everything from books to businesses. He has a unique grasp on the forces that are reshaping our world and how to creatively respond to them. Working on six continents, Alan has shared his knowledge in the form of board and advisory positions at companies such as Hewlett Packard, Microsoft and The Coca Cola Company, workshops, and speaking as well as teaching in institutions as wide ranging as Reading University's Typography Department, MIT, Sloan School of Management and INSEAD. He is the author of five books on creativity, marketing and business transformation including *Do Build: How to make and lead a business the world needs* (Do Books, 2021).

He runs immersive learning experiences for founders and organisations who want to make better things for better reasons, to create legacy and a regenerative world.

He still works as an artist. He tries every day to lead his life as beautifully as he can.

You can connect with Alan on social media: *@alansmlxl* or via his website: *beautiful.business*

Thanks

A very special thank you to **Johnnie Moore**, whose great wisdom and beautiful mind were vital in helping me to hone this book into a loving piece of work. And for that I am truly grateful.

Thanks to **Miranda West** and her team who did such a great job in editing, organising and agreeing to publish my labour of love.

To all the people I met on my way from all the places I have travelled, and to those whose books I read, to the natural world that always bring me great solace and serenity. I thank you all.

Books in the series

Also available

Available in print, digital and audio formats from booksellers or via our website: **thedobook.co**

To hear about events and forthcoming titles, find us on social media **@dobookco**, or subscribe to our newsletter